WRITERS' BRITAIN

ENGLISH VILLAGES

In the same series

ENGLISH VILLAGES

EDMUND BLUNDEN

with
8 plates in colour
and
26 illustrations in
black & white

PRION

This edition published in Great Britain by Prion
32-34 Gordon House Road
London NW5 1LP

Text copyright © The Estate of Edmund Blunden
This compilation copyright © Prion 1997

First published in 1943 by Collins

A catalogue record of this book can be obtained
from the British Library

ISBN 1-85375-247-9

Colour origination by MRM Graphics, Singapore
Printed and bound in Singapore

I

IT IS POSSIBLE TO FALL IN LOVE WITH ENGLAND'S great cities, and I have met people over the Channel who even looked back to their periods of existence in the dingiest parts of London with a fervour, a veneration, a radiant gratitude. Certainly there was more than sentimental recurrence to earlier years and vistas in their attitude. These friends of the Town had discovered not only the wealth of surprises awaiting the enthusiast in almost every part of it, but the extraordinary cheerfulness and frankness which spring up there under any kind of circumstances. It is not for me to run on into one more eulogy of London and Londoners, or to discuss other vast human hives in Great Britain, but let it be admitted that in spite of first impressions our cities have a way of making friends.

It is also possible to develop a considerable dislike for England's country places. I do not mean simply that they, like others elsewhere, can be dull in winter, 'droning dull,' or that it is not everybody who can be

interested very long when the talk is of bullocks. One of our most spirited critics of life, the essayist William Hazlitt—a man moreover who possessed a marvellous sensibility for nature and scenery—has stated the case against our villages in a tremendous piece of accusation. His grievance was concerned with the character of the country dweller. Before going any further, but without going into details, I will concede that there is something in the allegations of such visitors as Hazlitt. I could even add a number of things which he missed, or else which he found it inexpedient to begin meddling with; but like him I shall stay on the safe side. Two or three modern novelists have said enough on the other. The worst admissions that I shall make just at present, in respect of English country communities, are that the pilgrim will often find it horribly difficult to get a reasonable meal there, and that of recent years a dangerous amount of what is called education has been creeping into the fold.

However these things may be, of one thing I am profoundly persuaded, and that is that to the man or woman who is desirous of finding the best in this country I commend the English village. It is, of course, a wide sort of recommendation, for the term covers an astonishing variety of scenes and qualities and experiences; but my belief is that those who take the hint and set forth almost at random away from our big towns

BROADWAY, WORCESTERSHIRE, 1889

will soon find their rewards, and (what is always pecu-liarly satisfying) they will acquire treasure for the mind and heart which nobody besides will quite be able to claim. The English village is a very numerous creation, and its individuality will suffice for all of us to make our particular approaches and form our own bonds of sense and thought. Any map-sheet of a few square miles out in the open at once bears witness to the rich-ness of the chances. The very names, as we scan the said plain guide, arise with inducement to come and see the beauty of ancient agricultural conquest, touched with something of feudalism, and something of the monastic ages. I glance at such a map among sev-eral which have happened to be gathered on my table, and instantly the slavery of the pen is interrupted by a genius who pretends that I might this very morning be transferred on a magic horse into a region of exquisite freedoms. There murmurs an incantation of names: Dumbleton, Buckland, Stanley Pontlarge; Winchcomb, Woodmancote, Charlton Abbots, Sevenhampton, Brockhampton, Temple Guiting, Guiting Power. There come words, already almost pic-tures, of many a Manor House, Grange and Hall; of far older Tumulus, Camp, Villa, Ring; of Abbey, Chapel, Well and Moat, none of them made yesterday; with promise of Woods and Plantations and Parklands, the Carrant Brook, the River Windrush. . . . It is only a

HAWORTH CHURCH AND PARSONAGE 1857
'The vicarage—the parson's house.'

question of opportunity, and these invitations shall be honoured in full.

For immediate beauty of line and colour, one of the world's famous sources is Japan. The Japanese colour-print, which has delighted myriads of us, is not a product of fantasy. It is merely a summary of the real. So, I have felt a little anxious when I had the chance to act as host and companion to Japanese travellers who had resolved to see something of the territory known to them in the prose of Gilbert White, the poetry of Shakespeare and Meredith, the paintings of Constable and Gainsborough. It seemed to me, while they were looking forth from a hillside over orchards in bloom, and silvering intervals of rivers, and grey towers and brown roofs, that they did not feel a serious inferiority in the picture to the topographical truths of Hiroshige and Hokusai and Toyonobu. If their accomplished taste in sheer prospects and panoramas and vignettes was not unsatisfied, why should their guide dissimulate a certain satisfaction? Indeed, I felt like the landlady in a French village (a composition of flaring red brick and tinware, if I may say so) who handsomely responded to compliments on a gorgeous *repas*, 'Alors si vous êtes contents, moi je suis contente.' Yet the word which rings out in my remembrance is not concerned so much with the graciousness and the pictorial vitality of the country scene in England as with a more mundane,

St Peter's, Kent, 1865

'I could wish that every child had had such a place to grow up in.'

perhaps not less noteworthy, characteristic of a village. We were following the path across the hayfields and the old cricket-ground (ploughed up during the war of 1914–1919, and still in service for kail and sheep) when my friend the Tokyo professor, noticing a stately house encircled with a moat and fringed with tufted trees, asked what it was. 'The Vicarage—the parson's house.' He repeated with a smile of wonder, 'The parson's house!' I fancy it was the first time that he, a studious admirer of England for almost half a century, had truly envisaged the solidity and the dignity of each small world which acknowledges itself to be an English village.

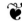

THE THAMES NEAR GORING
Water colour by H. Jutsum, 1816–1869

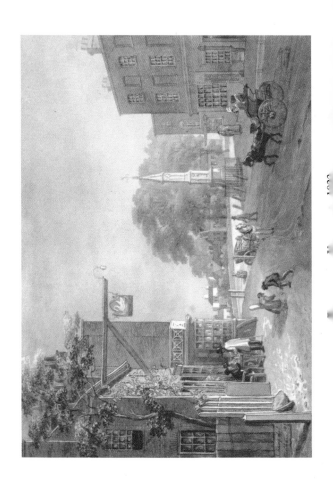

II

MY EARLIEST RECOLLECTIONS ARE OF SUCH AN English village, and I would not very readily agree to exchange them for any other kind. Perhaps it was, and you will pardon me for thinking it was, an exceedingly good example of our villages; in any case it provided me with a compact commonwealth of the most charming variety and possibility. I could wish that every child had had such a place to grow up in. We were neither of the wealthy nor of the needy sort (there were not many really poor people in the community), so that my memories may be regarded as more or less every one's in that setting; and again, as I continue to visit the village, I do not admit that my praise of it arises from the empurpling effects of absence and change. It stands the test of my coolest judgment. At the same time, after many years of wandering here and there among such places, I gladly grant that thousands of others exist through the land which would have been and still will be equally beautiful and chanceful and

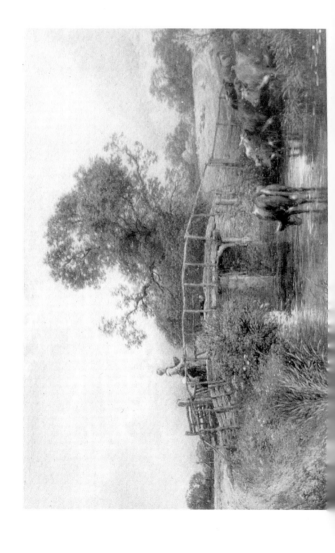

instructive to young people. My village was, and is, typical of many, or this would not be the place to talk of it. Let me attempt to draw its portrait, as it still appears in main respects.

It lies in a valley forty miles from London. The branch line delivers you at its station (which has now and then been repainted but otherwise stands as it stood eighty years ago), and you have a mile or more to walk. There are hop-gardens and orchards around, as well as a factory which supplies farmers all over the world with chemical preparations, and a paper-mill which used to produce the paper required for wrapping fruit for market. You soon cross the river and go along the short deep canal, cut in the seventeenth century, part of the old system of inland transport which has been declining lately. And here, where it joins the broad river again, is the contemporary inn, 'The Anchor,' which was originally (we believe) built for the bargemen, and now for years past has been a favourite anchorage for anglers, who have miles of water swift or slow to yield them sport. Should you climb over the footbridge into this beautiful inn, with its nooks and corners answering no particular scheme of architecture, you will hear good talk on local matters and some from the outer world. One word on this question of village inns: they are many of them, in the nature of little clubs, and the stranger even from a few miles distance

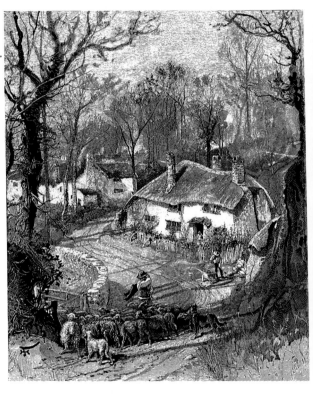

A Devonshire village, 1883
'We were neither of the wealthy nor of the needy sort.'

may feel for a little while that he is intruding on a private party. But, if he waits, he will be rewarded; the talk will warm up again, and in time he will be accepted as an 'honorary member.' The country will be revealed in glimpses. At 'The Anchor,' by the way, you may see some of the best sweet peas in the country, 'bloated aristocrats' of their race—while you drink mild or bitter, cider or something shorter. Once, our inns were there chiefly to offer red and white wine, but the national taste has preferred beer, the wine of the country.

Emerging, you will loiter on the long stone bridge which crosses the tumbling-bay, ever resounding to the fall of waters and their splashing hurry among casual mossed rocks and round the bastions. The bridge has its triangular recesses, useful still as heavy transport bangs across, and meant originally (so we agree) to give foot passengers escape from vast loads of wool on their horse-drawn way towards London. But that was long ago. This bridge, which still answers the wants of all our speeding traffic, is somewhere near or past its sexcentenary. Yet, such is the spirit of our village, a few of us are uneasy about it. Its name is Twyford, and in fact there is a ford across the river here, but people seem to forget. Quite a few years have flown since old Mr. H., careful of the rights of man, used annually to ride his horse through the river, assured that this ritual kept the

ford open to the public, no matter about the new bridge.

Here we might stay for days, putting up at 'The Anchor' and hiring a boat and tracing out the backwaters and landing in apple-plats and cherry orchards; but Yalding village lies still ahead, at the far end of this prairie with its mosaic of green meadow and swordy rushes, its chopped and twisted willows, its mantled ponds, its pound. Its pound? I hope it is still there. Not that it has much cash value. It is a small fenced enclosure, half lost in huge thistles belonging to the times when this stretch of land was in full use as a common, and smallholders pastured their few cows and horses here. Then, if one of their animals were found straying on the road, he was marched off into the pound, and his owner could get him out on payment of some small money. The last recorded prisoner of this kind is said to have been a harmless donkey, carried off bodily and lifted over the fence into the locked pound by some of our jokers.

And here, among abundance of chestnuts and elms and cedars and acacias, the village streets begin. They are by no means mathematically planned, but that is a general feature of these villages, resulting in rather more of detached beauty than of entire and immediately observable design. Another characteristic is that many of the best houses are concealed, or partly so,

18

beyond high red walls or thick shrubberies of cherry laurel and boxtree, so that it takes time and a good deal of peeping to find out the pleasures of this parish. The chief style of the houses on the street is still eighteenth century, an easy, balanced prose style of glowing but not glaring brick, and high roofs with attic windows, and sometimes an ornamental facing of semicircular tiles. The cottages are apt to be built of wood, in this district—weatherboard, a pleasant, simple material which seems to last for ever. Everywhere it appears that flower-gardens just arrive when people take a house in this village; the smallest space is populous with flowers of fragrance or splendour, but the inhabitants are quite accustomed to their own careless skill in conjuring these gay miscellanies into the sunshine.

You soon notice that the village is able to look after itself in many ways. The tradesmen's establishments are proof of that. The butcher, the grocer, the cobbler, the barber, the saddler, the ironmonger are here, though the brewery has become a haulage concern. There is the chemist's and the cake-shop, and if you want a dressmaker or a tailor we have them. In spite of the motor-bus, a carrier still makes his journeys to the nearest town and will be found a capital man of business. But, in that respect, should you pass much time in the place, you will be agreeably surprised by the supernatural efficiency of our village stores. They have

A BUTCHER'S SHOP, 1838

been of this standard ever since I can remember. Both are housed in ample, substantial eighteenth-century buildings, both are crammed with every sort of article. I have been informed on good authority that Mr. P.'s line in ladies' silk stockings is inimitably fine, but then so is his bacon and his cutlery; and Mr. C. is the man to go to if you are wanting a curious and beautiful tea-set or a silk eiderdown quilt.

These things are mentioned because it may be supposed an English village is a primitive collection of people and habits, where that country bumpkin Hodge who has been so much and ill used on the stage and in humorous publications drags on his feeble, under-nourished and unreflecting life. Without arguing that outlandish corners and hard conditions are not to be found, I can yet say that such a reasonable prosperity as we see in the shops, the buildings, the faces and the occupations round us in this village is familiar throughout the country.

But to continue our walk. The village is built about a river and its creeks, and needs the town bridge with its many arches which was once so narrow as to be used by pack-horses and foot passengers only, and then—at a date long forgotten—was widened for carts. It is a living relic, and so is the butcher's shop which stands on it in the ancient fashion. Its stonework harmonises with that of the church tower just north of it—rising

well above the mixed group of shops and dwellings and inns and alleys which seem like its brood, under its protection. The tower is square, with grim window-slits, but it wears at a corner of its flat top a queer cupola resembling a large green onion (an early eighteenth-century fancy), which adds an effect of friendly humour. The church is large, and has details which, to the discerning eye, chronicle the history of several hundred years ; but of course most of the memorials do not go back beyond the Cromwell period, though we trace our vicars back to the Conquest almost. Here you may read specimens of lapidary verse and prose of great elegance, proper to the costly alabaster on which they are so finely chiselled; and here in gilded lettering the terms of former benefactions to the poor of the parish perhaps survive the actual application of them. There is a singular union of austerity and of intimacy, to my feeling, within this church of many painted arches. It is, to be candid, not one of the celebrated examples even in our own district, but as one walks its aisles and thinks that scarcely a real village in England is without some such fine piece of sacred architecture, then the question whether our great centres of commerce are mainly ugly or not loses its importance.

At the door, you glance at one of the official fly-sheets tacked to the notice-board, and you remark with some bewilderment that it is a warning, to folks of this

The grammar school, Steyning, Sussex

world, about the next payment of income tax. It is a practical demonstration of the old alliance, Church and State, and equally of the everyday contacts between our village and its own church; there is the centre still of more affairs than are readily catalogued. Perhaps you miss the dreaming form of piety as you scan our house of prayer—but the village has its own devotion to that house, and so far shows no signs of following some more modern symbol. The church tradition, with its ceremony, eloquence, music and morality, is too deep to be soon lost.

You will ask about our schools, perhaps; and then I must be allowed a sigh of regret. That gabled, rosy building at the top of the street, its windows glittering through the line of chestnut-trees, was till lately the Grammar School, with a very lengthy history, and quite an atmosphere of learning; farmers' sons from the surrounding country, and aspiring children from the village, used to come here and get some Latin and French and mathematics. The last Great War was its ruin. It was, I suppose, unsatisfactory in every respect as a modern school—and yet, how the memory of its lessons and customs sweetens these days! The buildings still serve the village; the boys' club or the nursing associations occupy the gaunt rooms where the 'poor usher' once droned away at the world's Famous Rivers or the Elements of Euclid.

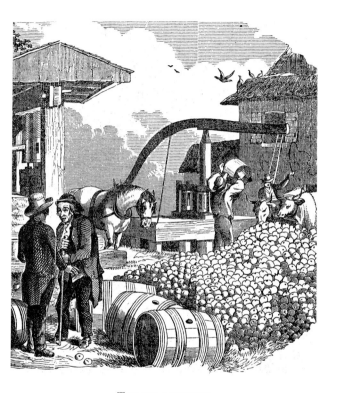

THE APPLE HARVEST
'. . . the apple orchards with our strong labourers.'

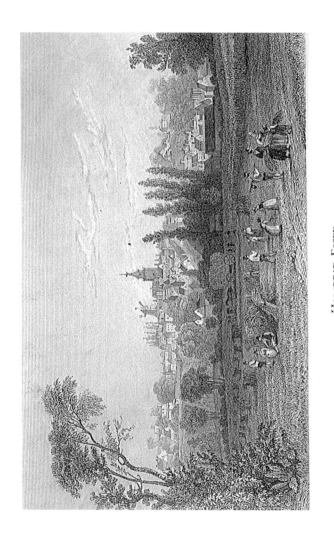

HAMPTON COURT.

The village schools for infants, girls and boys are, like many more in England, the products of early Victorian effort; their little steeple, their pointed windows, their stonework all have a church look. They are as they were built, almost a hundred years ago, and I could sing the praise of the generations of teachers who have worked modestly in them and whose work may be tested by the friendliness and good conversation of the young people we meet on our walk.

Religions, for us, are few: Church and Chapel. The Baptist Chapel, a neat brick building, dates from the later years of Queen Victoria. The village does not dispute over its forms of worship, and I think we see the vicar and the minister having a cheerful talk this moment on the roadside.

A few great houses in our parish are still regarded with a degree of veneration. Not many years ago, they were truly powerful influences in our community, and even now, when wealth is reduced and the social order modified, they are relied upon for various kinds of leadership. The buildings are maintained, despite the problems of our time, in beautiful order, and their lawns and flower-beds and ornamental trees as yet make a rich picture. Hereabouts the passion for planting rare and exotic trees and shrubs has been general, and you find even a little wilderness of bamboo by the old mill pond. The touch of the East is felt even in the

27

low stone wall below this triangle of pines—the stones are set in an oriental pattern.

If we passed by the cricket and football ground without a thought, we should make a great mistake. Perhaps it is a mere coincidence, but this green level is part of a wide meadow the name of which preserves that of an old sport, the Quintains. Not many miles from here, one may chance on a village green where the apparatus for that medieval tilting is, or lately was, visible. Our great game is cricket, our summer is incomplete without its encounters and its old and young assemblies of spectators, and however the actual process of play may seem to the uninitiated visitor, the entire scene within this zone of woods and pastures, with the pigeons flying over or the cuckoos calling across, and now and then the church clock measuring out the hour with deep and slow notes, cannot but be notable. Then, if ever, our desire for peace, but our desire for a contest too, comes forth in its most gracious and equable picture. I would paint any one of these boys, in his white clothes, with his ruffled hair, his keen and serious face, walking forth with his bat in hand, as a portrait of whatever is truly fine and serene in our national character.

The village, which has thus been briefly charted, is surrounded and intervalled with the farms on which its life has so long depended. This part of England is what Byron called 'a paradise of hops and high production.'

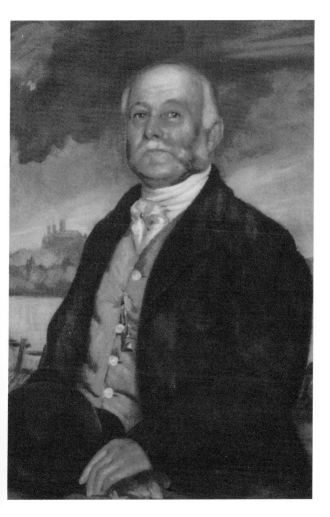

A YEOMAN FARMER
Oil painting by Neville Lytton

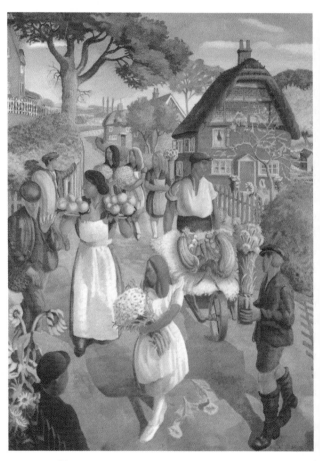

THE VILLAGE FLOWER AND VEGETABLE SHOW
Oil painting by Gilbert Spencer

The apple and cherry orchards perhaps extend more widely than the hop gardens; and there are fields of loganberries, of strawberries; soft meadows for grazing; wide lands whitened with hundreds of ever hungry fowls. In the time when the fruit-trees bloom the whole scene, viewed from the hill where the spring-well gushes forth for ever, is exquisitely gay and young. Then, later in summer, the hop gardens are the show-piece, with their long shady green tunnels or aisles of leaf and berry, and their high hedges curtaining them from the winds. But then again the scene of the apple orchards with our strong labourers in their jerkins busy on their ladders, or stacking their bushel baskets of bright sound fruit, is alike beautiful and purposeful. In many other aspects, if I may be permitted the reflection, such a village deserves to be well-liking and well off; for its folk have treated Nature kindly and cleverly, and are still thinking how they may improve on the knowledge and method of yesterday. They possessed these lands long since, but have never fallen into the mistake of thinking that possession means sitting still and hoping for the best.

Up on the hill (whence you can almost always look forth upon a vast tract of valley land perpetually changing its tints, its lights and shades even though the day seem steady) there are ancient hollows and quarry-ings in the chalk, where bramble bushes dangle and the

elder brings its greeny flowers and purple-black clusters of berries. Ancient they are, but not so as to have out-distanced the memory of the village. From these, it is still mentioned, the village church was quarried, and that is quite a long while since. We do not remember everything, it is true; but no matter how many of our families die out or depart, how many newcomers (we are very near London after all) settle into the street, quite a number of fragments of history continue as parts of our life. The windmill which used to grind our corn has long ceased to be needed, and is gone alto-gether; yet I hear the boys say, 'We're going up the windmill,' as they cross the green. The place abounds in names of localities which have every one of them a meaning for us: the Turkey Pond, Crow Plain, Sunday Dip (do the boys still dodge church to splash about in its warm shallows?), Pikefish Farm, Wolsey, Cheveney, Emmet Hill Lane, The Tat, Rat's Castle, Lughorse Lane, The Ring, Benover, Little Benover, the Ballast Hole, Collier Street, Two Bridges, Kenward, Bow Hill, the Barge River, dozens more. So that, if you come to live among us and have a feeling for these things, you may trace a whole multitude of peaceful histories which unite this country community with the England described by our poets in the fourteenth century, Chaucer and Langland. It has been all along an unostentatious, a good-tempered tradition, a work of sturdy character

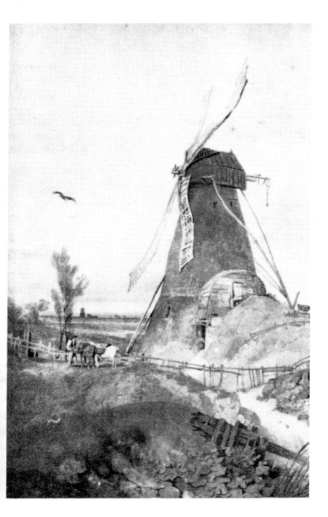

A WINDMILL IN LINCOLNSHIRE
Water colour by John Sell Cotman

content with native fields and the honour of a local achievement.

But to that summary of a race of healthy, sensible, industrious and capable people one addition has to be made. We were never expecting to make it. We do not even now quite comprehend it, except in large terms of what may be demanded of us by those who know more than we do, and what we are prepared to do, endure, and give without arguing at the wrong moment. On the green, looking down the village street, a cross has now stood for some years. Upon its pedestal there are inscribed the names of those who died, in His Majesty's service, during the war of 1914–1918. And here, in truth, these men, or boys, are not forgotten. They are remembered not as soldiers or sailors, but as some of our parishioners, this one clever at figures, that one given to practical jokes at the bakery, another who was to have married the beautiful Alice C. They have all come back to us. They left their rifles and bayonets, their belts and bandoliers (which they took much pride in) at the place appointed, and are always somewhere about our houses or farms, getting on with the things that in the end mattered to them and us, seeing that the barrels of sulphur for the hop kilns are delivered or that the old cob-nut plat is grubbed up and new fruit-bearing trees are put in.

III

IN SUCH A VILLAGE AS THE ONE THROUGH WHICH WE have walked, some characters are to be found in whom a marvellous richness of the spirit of the place is concentrated. They are Shakespearean. That is, they illustrate that union of pervading reasonableness with lively curiosity which our dramatist exhibits in full. To them, and in them, life is many-coloured. I do not propose that we shall draw them out at a first meeting. That would be to contradict myself: these are wise men, and women. But one of their virtues is, that they are eminently companionable, and once they have accepted us as friends and of goodwill, they will not easily draw back from a desire to share their world freely with us.

There is an old English word, which has grown a little antique, but for which no good substitute is as yet ready, occurring to my mind in this place. It is the term 'a yeoman.' Professor H. C. Wyld, in the most useful of modern dictionaries of our language, traces the history

of its meaning from 'manservant' or 'steward'—with a deep *village* connection—on to an 'owner of free land to the value of forty shillings yearly, thereby entitled to certain rights,' and thence with the passage of the centuries to a 'farmer cultivating his own land, a small landowner.' Some biographers inform us that Shakespeare's wife was the daughter of 'a substantial yeoman.' Without exploring the details further than this, I can say that the word is the nearest I know to expressing the kind of man who keeps our village going. 'Peasant,' which perhaps would once have had some suitability, has now ceased to be applicable here. Even such later ways of allusion as 'the rustic,' 'the labouring man' do not quite fit our worthies, in this kind of village.

Mr. A. C. has been, ever since I can remember, the very picture of a substantial yeoman in our village. He has never tried to be anything else, but has shown throughout his life of more than seventy years that this may be a masterly kind of achievement, and of deeper importance, stronger influence, fuller variety than many forms of activity which might be supposed more noteworthy in the world. His function, since his early life, has been that of bailiff on our biggest and most successful farm. His old employer has departed this life some few years now, and in a manner A. C. has retired, but in fact he cannot by temperament retire

34

until he is past moving his legs; so he continues to be connected with the farm and in the councils of the sons of his former master and friend. And he is for ever, so far as I can see, one of the unofficial rulers of the village.

If we happen to see him walking down the hill with his bag of fruit or vegetables intended as a present for someone, you will agree that there is authority visible in his outward figure. You remember something like the appearance he makes, in the paintings of Teniers, or perhaps it was he who was scanning the fields and plantations along 'The Avenue' of Hobbema. That broad frame, that good round red-cheeked face, those bushy whiskers—the almost stately but very alert movement—they proclaim a local command. Yet it is so far from being anything of a tyranny that all our young men converse with him as freely and candidly as they do among themselves. To him, many problems of a village life are brought, and seldom in vain. Either he knows the answer, or he knows who knows. It might be a question of gardening, and if it is, it will be a curious one, since almost every one in the place is already skilful in the subject. It might be something on farming alterations, or experiments, or equipment—a wide field of possibilities, in which his experience, memory and sense will seldom be at a loss. Perhaps some dilemma of personal conduct, of love and friendship or the opposite, may be submitted to his wise, honourable and still

kindly old mind. Maybe a young man is proposing to deal with some property, is invited to speculate, is able to consider a big change in his business; then A. C. may not be willing to press his own opinions on the case, but having all along in his own affairs kept the gift of getting advice which worked out well, he will soon be able to throw considerable light on the prospects.

In his time he has seen much, learned much, and has never felt the pride which refuses to admit that a man may learn from his betters; it has been his intention always at least to be fit to bear them company. He perceives the general lines of interest and occupations and thinkings with which he is naturally not always concerned. He has tried most of the sports and pastimes of our country, and made acquaintance with many callings and professions. His speech is a constant, unforced but energetic attempt to state things fairly and in proportion.

With him will often be found—and the fact is one of some significance to one who would interpret our community—a contemporary of his, to whom also the younger generations come with affectionate trust and openness. This is the retired schoolmaster, who could almost be called a yeoman too, so much is he on that model—but he, of course, introduces another background and view of life, perfectly in harmony through almost half a century with the qualities of A. C. He has

been, for so long a period, a source of information and reasonable judgments in this village community, one of the characteristics of which is that it respects accuracy and deliberate carefulness. Through him and his quiet presence, the local interest in music has been strengthened more than a little; from his shelves many good books are passed round and enjoyed; if it comes to a point of mathematics or other calculation as part of one of our discussions, his delightfully clear and intelligible way of working it out with us is not only of practical and immediate value but is also felt to justify the intellectual side of things, among men and women whose lives are more concerned with materials and manual skill. In short, he is the scholar whose abilities are honoured here and whose measured views have a great influence on the attitude of many to the world around them. In him, as in others of some eminence among us, a remarkable power of memory is constantly in use, which provides interesting and profitable examples, parallels, suggestions even on topics such as he has rather observed than had the opportunity to test in personal practice.

This gentleman employs, in an informal kind of way, one or two worthies who could flourish in a novel by Thomas Hardy. Take for example S. M. He may be seventy years old by now, but nobody notices it and he does not. He has in his time done all sorts of work, so

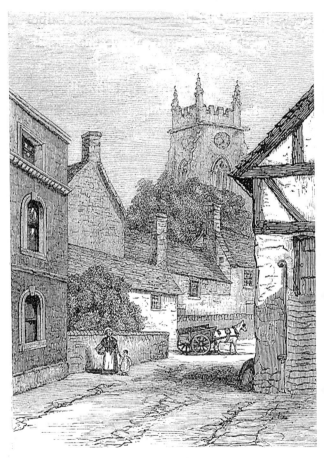

MARKET DRAYTON, SHROPSHIRE

many that he often repeats the proverb at his own expense, 'Jack of all trades, and master of none.' He looks rather like Mr. Pickwick, had Mr. Pickwick been born to a great deal of tough labour, and beams forth behind his spectacles with a world of benevolence—yet his critical powers are there sure enough, as many a boy in the parish knows. For many years he drove the baker's van, and through that and other occasions he knows every corner not only of the village but of the district; he knows the lands, the farms, the woods, the weather, the haunts of beast and bird. His cottage was the last in which I heard, in this village at least, some fragments of the ancient mummers' play of *St. George*; and there I have listened with delight to his commentary on the doings of one and another, on the old ways and the new. I don't know how, but his personality is ever associated for me with rosy-ripe apples, and great wicker baskets of walnuts, and mighty barn doors with the sun staring in upon goodly stacks of fodder. Himself utterly frugal, he has the gift of making plenty attend him; and you may be sure that wherever anything calls for immediate and unexpected action he will be first on the scene and first with a workable answer. If he has a foible, it is for his reminiscences of dialogues with the learned and the opinionated. Perhaps it was some question of a horse's illness, fifty years ago, when he was given peremptory orders as to the treatment due;

but, as he recites the conversation that passed, he knew the more excellent way, and he stuck to it after a number of laconic moves and parries which left him in fair possession.

His wife, 'a woman peerless in her station,' has as much good humour as he, and a similar quality of fine judgment in all that passes. She has the same delight in doing things well, and can do many exceedingly well (not excepting the making of home-grown wines). To speak with her on a dull day, when the news perhaps is none of the best, is to win a bit back from the fates. She has never thought of winning much herself. She and he, long ago, quietly accepted their lifework, and made their place. Good example was given her in her early years, and the pattern is preserved in its original grace in all she does; it may be that the state of society which she was shaped in is gone or going, but there is as yet no such difference that her household skill and her quiet mind are baffled.

Of the younger villagers, it may be briefly remarked that they have seen more of the world and have discovered more opportunities, without losing the plainness and steadiness of outlook which you cannot but feel in the whole visage of our streets and gardens. They are not the sort of people to select if you are thinking of writing a homily on the decadence of the Englishman. They will not do, if you are meditating a

THATCHED COTTAGE, 1899
'An Englishman's house is his castle.'

thesis on the Peasant or on the Prevalence of Superstition in Village Communities. Many of them are technically expert; and still they have from the first a tradition which enables them to tell, like Hamlet, a hawk from a hernshaw (a Jack Herne, they call him, just as S. M. does). They have it in their hands to grow things, and build things, and drive things. But we must leave them talking with the ancients over the new machinery, or the old schooling.

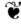

THE KING'S HEAD, AYLESBURY, 1879

IV

WITHOUT OR WITH A MAGIC CARPET, WE HAVE NOW arrived in an English village of decidedly different aspect to that we have left in the Home Counties. It is one which, in spite of a large outer layer of fragile recent villas and bungalow affairs, presents much more of the mediaeval in its outward appearance; but that may be partly due to the fact that it is built in stone. The Georgian architecture with its bland white face has not affected it very obviously. Crowning a big hill, with a tremendous river valley under its eye, this village is grey, and its share of thatched roofs does not disturb that total look. Is it only the illusion of its strong rough stonework, that it announces a life of strenuous and slowly modified farming and smallholding? The gardens here are small, the orchards scanty, as though the vast plough-lands around had always demanded too much of the inhabitants for any such amenities to extend; and the houses themselves, the walls about the closes, the stone fences along the lanes and the fields

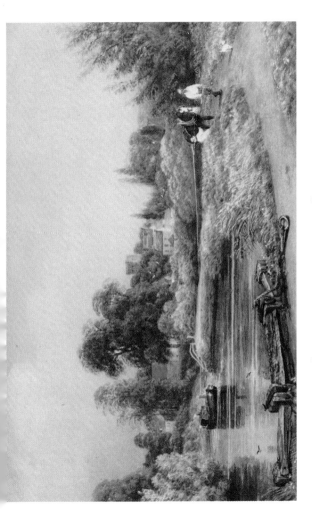

IFFLEY FROM THE TOWING PATH, OXFORD
Water colour by Peter de Wint, 1784–1849

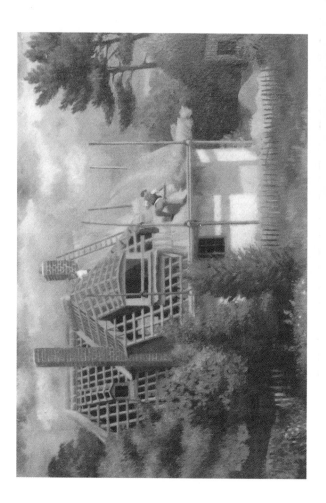

have a semblance of fortresses. 'An Englishman's house is his castle'—the words take on a curious significance as we look at these cottages and farmhouses.

That inn there, for instance, the 'Bear and Ragged Staff'—what a countenance of rugged durability it shows. With its massive chimneys, its bastions, its out-buildings, its thick walls, its angles and high gables, it might have been set up in ages of small wars and provincial feuds, the headquarters of some determined faction. It may not be as old as it looks, and that might be seven or eight hundred years, but the detail of an exact date does not matter much when we see so boldly expressed the genius of the place. The place is isolated, the winds blow fresh and eager over it, and if man will but be strong, nature offers him the material for his lasting establishment. The men who come to the 'Bear and Ragged Staff,' I take it, will be of a certain sto-icism. There is in my memory a scrap of talk from the winter of 1939: enter a labourer, with a cheek like brown parchment and inscribed with records of for-tune as much as any old parchment:

Labourer: Got any bitter to-day?
Landlord: No, I'm sorry, Tom, none in the house.
Labourer: Got any mild?
Landlord: No, that's not come in yet.
Labourer: Got any good *rain-water* then?

With the inn, the church divides the domination of this hilltop cluster of homes in stone. The great house, with its ghosts of national history, has vanished altogether, though its place remains unoccupied except for a thicket of elder trees, and crab-apples, and sycamores. The church is glorious, and the people are proud of it, and keep it well. It is set on the highest ground, and its square tower though not lofty marches through the sky as grandly as though it were something much more ambitious. Its graves are arrayed at its foot, solid and erect stones, seeming too to be watching the lands stretched below their grassy terrace. The interior of the church is a chronicle of centuries extant in a number of carefully preserved forms exceedingly vivid—those sculptured heads along the wall—some, enigmatic portraits; some, fantastic emblems; one or two, studies of personal truth; then, that, full-length and agreeably plump statue of Queen Elizabeth, with her richly decorated costume; or, for you to find by looking cleverly, the elaborate wood carvings of some master of scriptural idea; again, the displayed and splendid copy of the Authorised Version of the Bible, 1611, appointed to be read in churches and in its form truly worthy of the national religion.

Many a footpath winds away from this centre through the farms, and towards lonelier farms, and it is no wonder that Matthew Arnold's Scholar Gipsy made

this his haunt among others congenial to his dream. We might follow him into the valley of the Thames, down the stony desultory lane and then through the leys by the green track, to Bablock Hythe with its ferry. What a stillness, what a sacredness we find within a few moments—and still it is the village, and someone on business is hurrying past us to the farthest house. The blue distances beyond the high and casual hedges might go on for ever, and so this wide track might go, but at length it finds the wood, and passes the Physick Well, and brings us to the 'stripling Thames,' with the sunlight on the shallows, and the warblers in the rushes, and the horses loose to graze in the sweet pastures to the brim of the famous river. If you would explore, I can hint at a grove of willows not far away, grotesque trunks and serpent boughs complicated into a place truly beyond the world; but every good village owns some such capricious scene. In the other direction, the quarried Hurst shines to any blue sky, and indeed the sky seems unusually blue there; the hillside burns red and orange, and its green crest is plumed with black fir-trees—a picture indeed for youth to eye with constant fancy, and for age to mark with revisitations of faith in the beauty of the scheme of things. This also is of the village.

But I shall insert here the words of an official memorandum: 'It is an ordinary village: it is not a show

48

place. Submerged by an overflowing town, it would all go under together, and be lost in a suburb. But it is still a living village, a centre for people with country ways, and with miles of agricultural and purely rural areas behind them. Its character is formed by the old farms and cottages scattered round the church.' A census of its old farms and cottages, such of them as are at all characteristic, only runs to about forty entries; and yet I believe that, if you are captured at all by the spirit of this tiny aggregation, you will have the impression of some much greater number of dwellings. At least, you will probably not notice at all whether there are few or many. You will certainly not have converted the village, by too generous a sympathy, into one of those which worshippers in this field have long named and bepraised, honoured with verse or prose or painting; it is an unadorned, unconsidered place when all is said. Nevertheless, like so many of these villages in England, its character is compelling, and emerges and surrounds the sense of those who pass that way beyond all reckoning in the terms of a census. I suggested it in the figure (which I desire may not be pressed too far) of a stubborn old fastness, a domestic fortification devised by rather lonely men to confront a rather austere though workable wild nature. At all events, there it stands yet, quiet, dignified, grey, and in command of its hill and vale.

V

AT A DISTANCE OF ONLY A FEW MILES FROM THE village last sketched another has long charmed me, but its essence or intimation or phantasm is quite different. There is no particular claim to make for it, among the villages of England, except that it is a good one of its kind; and it does not challenge attention where it lies on an off-road. It has not produced celebrities, and I suspect history has evaded it without difficulty.

Its charm is easily summed up—peace, or sweet content. But this is not an unusual attraction in villages anywhere. No: yet here the scene to which the by-way or bridlepath leads us is peculiarly communicative of such a blessing. We come out upon a broad and level green, restful to the eye at any season and elysian in the flowery months, along the margins of which, each in its own easy way, the main part of the cottages appear. There is nothing rigid in the design; the green wanders into corners and projections, and buildings care nothing

50

for alignment; but the whole is a model. These small cottages, thatched, timbered, colour-washed, or in ripe red brick, are just what they should be as the neighbours of that grassy arena; wide enough to pasture all their cattle, and to enfold all their feasts and sports and children at play. I do not mean by this to allege that one finds in this village an idyllic pastoral life in detail. 'Labour's only cow' is not the modern way, and wakes and Whitsun-ales and dancing on the green are rarer than we hear they have been. But the memory of a pastoral antiquity is persisting here, and if one's fancy were to assert that the merry milkmaid of Izaak Walton or a piping shepherd or a dance of harvesters were now in the picture it would not be false to the feeling of so unworldly, so gentle a place.

There is a post office. There is a butcher's shop. These valuable facilities of civilisation are commonly quite emphatic of their presence. Not so in this village. You come upon them with surprise, hiding away privately among the rest of the cottages. The village is, so to speak, private. Its outlying houses are beside or at the end of narrow lanes with straying hedges, as if they would be of no interest to any one but their tenants and the four seasons. A church in the fields is suddenly surprised, like a hare peering over a patch of oats. The highroad is not far away, but the distance may be measured in other values than miles. The speech of the

CHERRY TREE COTTAGE, CHIDDINGFORD, SURREY *c.* 1890
'Its charm is easily summed up—peace, or sweet content'

people sufficiently declares that.

Where the population is so small, the wonder is that the community can do much beyond its separate occupations; but it mostly finds things to do apart from those. A stranger may wonder even that the farm lands are cultivated as they are; he may see the men who manage that, assembled on one occasion or another, and it will still seem remarkable to him that this little group of villagers, not all of them giants or even robust and potent in appearance, keep so many acres and so many animals in order. Besides that they find time and vigour for their cricket and football matches, at home and away, and then they see to it that the choir, and the bell-ringing, and social clubs and local councils continue from generation to generation.

Glancing back at the village on the green, I cannot repress a sigh of happiness that we have not as yet reformed our country (as Hamlet says) 'utterly.' I am afraid that the latest regulations on housing conditions, applied in coldness, might quite suddenly disenchant that scene. What we have to do, and a new spirit will surely find the means, is to continue it while we improve the material conditions within it. But there is something more. The village must be still the villager's own, and that is not so easy as it sounds. Fortunately the Englishman on the whole perceives that he cannot merely escape into ruralism, or be a detached spectator

of a delightful but unrelated way of life. It is in him to rejoin it, to be part of it, and in due time to be quite naturally one of the dancers on the green, or thatchers on the stack, or scythesmen in the lower field.

The days of the great houses in our country life have passed, though some illustrious survivals could be pointed out; and yet it is reasonable to expect that the village will flourish anew. For years many have been inspired with the idea that its labour and its reward compose the best and happiest of lives, and it has been the subject of a host of writers, who have been at pains to discern and delineate the wisdom and the abilities of the English countryman, as well as to affirm the wealth and use which could be gained for the country by following him. It would be far from astonishing if in the period of economic revision which is now expected after the War, something truly energetic came of all this; if the village in the end proved the salvation and the fulfilment of England. Why, even those ardent lovers of yesterday who go about, God bless them, forming bodies for the purchase and maintenance of windmills may find that their piety has been converted into realism; but we must see whether man can ever set his scientific novelties in a balance with the possibilities of simplicity.

Again travelling a few miles from a typical village, I take leave to pause at another which the connoisseurs

WHITCHURCH, DORSET

'It is an ordinary village: it is not a showplace . . .'

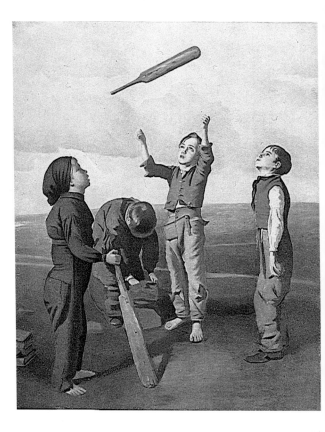

BOYS TOSSING FOR INNINGS, NINETEENTH-CENTURY
'Our great game is cricket, our summer is incomplete
without its encounters . . .'

found out years ago—a considerable, rambling place, with several mansions secluded behind stately walls, long drives and copious shrubberies and trees. What a village of great trees it is; they have been planted with faith or imagination, and they build a huge archway over the road, wide as it is. A spacious kind of village, this, the creation and the care of a whole squadron of squires; but it is on the river's banks that the stateliness of all the domain is finest. For here, a series of weirs produces below the main stream (and that is majestic) a chain of pools, ever in bright unrest, the beloved waterworld of bathers and anglers—one might add, lovers. Gardens and lawns approach this romantic and bowery and many-coloured river paradise, but from the village street, where the old houses rejoice in variety of shape and decoration and tint, a traveller might not guess it was there. It is like many of the beautiful things within the English village, unhonoured or uncursed with signpost or descriptive invitation. Should you hit on the narrow path behind the ruined mill (which is behind an unbeautiful wall), then you may have all the luxury of the first discoverer.

Maybe we should not always leave the pleasure that our villages afford to chance, for some of them come and go quickly. Events of local fame might be worth a wider circulation. There is one in a solitary yet not at all declining village, within an hour or so of

Oxford, which might make one fancy that the ride had ended in Brittany. The Bampton Morris-dancers, a club of old and young men, blaze forth in all their bravery once a year. They strut and hop and frisk then, to the tune of the fiddler with his kit, in the market square, and are clever and merry enough to bring round them an even larger crowd than the cricket match in the field beyond the church, though that is a perfect summer picture too. An 'all-licensed fool,' equipped according to eternal law with a bladder on a stick, and flushed alike with exercise and drink, scampers round among the dancers, with many complaints and jibes against the 'lazy rascals,' and is one of the most popular parts of the entertainment. It is an ancient flower-ritual, by all appearances, and exists not by revivalism but by continuity of tradition.

In such a village, tradition proceeds comfortably along and modernity does not dispute the right of way. Inevitably the population includes its proportion of bright and smart young men whose business is in the town and who are acquiring a 'position' not much connected with the village in which they have run up a bright and smart little house. But it is not sentiment to remark that a picture drawn by an accurate hand more than a century since is still true to life in many of its small points and in its ultimate impression. 'The Cottager' is still alive, and the village, anywhere at all

remote from the big commercial hives, is still very much dependent upon what he hides under his battered hat:

> True as the church clock hand the hour pursues
> He plods about his toils and reads the news,
> And at the blacksmith's shop his hour will stand
> To talk of 'Lunun' as a foreign land.
> For from his cottage door in peace or strife
> He ne'er went fifty miles in all his life.
> His knowledge with old notions still combined
> Is twenty years behind the march of mind.
> He views new knowledge with suspicious eyes
> And thinks it blasphemy to be so wise. . . .
> Life gave him comfort but denied him wealth,
> He toils in quiet and enjoys his health.
> He smokes a pipe at night and drinks his beer
> And runs no scores on tavern screens to clear.

The fortunate lover of our unspoiled villages will know that once such an inhabitant is led on to talk without restraint, the lights and shadows of what at first looked unvaried become multitudinous; the spirit of the village reveals itself in a leisurely but vivid versatility. It is seen, quite as happily as in the Georgics of Virgil, working away at a number of time-honoured tasks, summing up the problems of life afield or in the heart of man, conjecturing over the strangeness of

MOSTON: A NORFOLK VILLAGE
Water colour by Martin Hardie

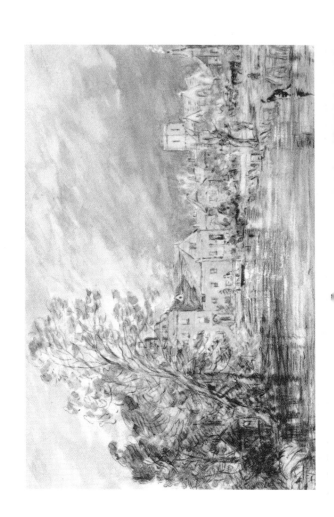

some localities, some hours, recalling the triumphs or
the disasters of the individual, noting the odd things
which a country life encounters in the spheres of the
insect, the bird, the quadruped, the fish, the herb and
flower and tree. This is the spirit which acknowledges
that stones grow in a certain field, or reasons in favour
of the horse-drawn plough against all comers, and it is
to be allowed full freedom; for in its own world it surely
knows its part. But besides the lore and the practical
intuition, the excellence of this old miscellany moves in
the keen and apt phrase, the tune of the speech; which
you may call dialect if you will. It is a wording and a
shaping of the earth earthy, and of the oak oaky, and the
pity is that, as with the fascinating talk of men of intel-
lectual and experimental greatness, it is exceedingly
hard to do it justice in any attempted transcription.

You may collect specimens, or compile glossaries,
which will be delightful as far as they go. The list of
these is already legion. If one of the best may be men-
tioned, it is the work of the late Rev. Edward Gepp in
the county of Essex, which he published only twenty
years ago. But all the right country conversation is too
subtle and involved in circumstance to yield to analysis,
or rise up in its fullness from a record. It is of a kind with
the voices of the thicket in the wind, or the sounds of
the barnyard on the first blessed day of spring. But it
can be awakened by the deserving, in the 'native heath';

and sometimes a ride in a market bus will be rich
with it.

Yet another pleasant and natural way into the inner
mind of our English village may sometimes be opened.
At times there is, in any friendly little gathering away
from the day's work, a tendency to get a song or two
started. Maybe the merits of the singers, as singers,
would not be considerable; but what will gratify the
onlooker who is admitted without ado to the group is
the queer selection of the songs. It is not a matter of
what are officially called folk-songs, the study of some
inimitable masters of the subject, but of a drifting ele-
ment of popular pieces, one can hardly guess whence,
or why they appealed sufficiently to be memorised as
they have been. They are performed with a certain
painfulness, or high seriousness of manner, for the
most part, and are treated with corresponding
respect—at least they were when I was last one of the
winter night's audience. It is curious, now that I reflect
on it, but I have never heard one of them again. Each
man, who is at all able to contribute to these solemnities,
appears to have his own property in the way of old songs.
Nobody indeed would want to borrow them from him on
sheer grounds of music and poetry, but they illustrate the
country mind and the different ways in which the village
feels about the interests of life and occurrences of his-
tory.

When Long Henry has ended his doleful ditty about an emigrant and his mother, and has settled back in his chimney corner to puff smoke at the ceiling in deep content, it is possible that we shall have appreciations of a local incorrigible. In fact, he suddenly comes in, amidst croaks of welcome—old Banjo Bert— marvellously attired in a kind of game-keeper's velveteens with foreign coins for buttons. He takes his time with the company, who accept his very presence for a millennium of wit and drollery, and then, seeing you in your place, and being in sober verity as kind a man as there is, he devotes himself to your edification and recreation. He supposes you are interested in what is old and valuable—why then, he produces a monkey's head carved in bone, or a snuff-box which you never will be able to open unless you have the secret; these are really old, these, however, he wouldn't part with for a mint of money. Then, you must be a clever man if you can follow all his riddles, or you must be a slow man if you can't catch his meaning—listen to this, 'I saw a white blackbird setting on a wooden tomb-stone.'

This roving gentleman must not be lightly laughed away. He has come down the ages. He has an eye. He lives so, as to sharpen some sense that does not grow within the pale of normal citizenship. He can do lots of things when the appliances of this century are missing or do not fit; but that is not his faculty alone in an English village.

VI

AN OLD FRIEND OF MINE, MR. H. J. MASSINGHAM, has been busy collecting all kinds of country implements, which he describes in a delightful book. Many of them are superseded and perhaps almost nobody now in a village would recollect the uses for which they were intended. After all, the effects of industrial progress on common life have been going on intensively for a very long time. William Wordsworth, who died in 1850, lamented the disappearance of the spinning-wheel from the cottages he knew many years before that. And there were all sorts of less prominent devices of country craftsmen which shared that dismissal. Tools, methods and the passion for accomplishments have changed, and one starts up in surprise in reading the novels of Thomas Hardy at descriptions of much that was once familiar and necessary, now never thought upon.

It is not possible, however, to do without the craftsman of the old leaven; he is still with us—the

maker of gate and fence, the builder of rick and lodge, the sign-writer, the weaver of basket and hurdle, the worker in old woods who can reproduce famous styles of furniture, here and there the ingenious craftsman in iron, not to mention all the aspects. Without joining the ranks of the mediaevalists, one may easily think the day could come when our village should be newly interested in its own handiwork, and resuscitate forms of skill and contrivances belonging to them which have been under a cloud.

The signs of the local dexterity of yesterday are as yet quite abundant in most of these places. The large and handsome clocks which are still on duty in houses of some tradition often bear the name of a maker who flourished in a village. They look like the firm predestined chroniclers of unhasty hours. The present clock-maker could make more of them, if the economic system encouraged him. There are still at one farm and another examples of those majestic wagons which reminded Thomas Hardy of three-deckers on the ocean, productions of wrights who 'dreamed not of a perishable fame' but brought a collated knowledge of materials and processes into the service of a hundred years. And the business did not end without elegance. These vehicles were finished as nicely as the faces of the grandfather clock. Incidentally, the bold colours which adorn the labour of village agriculture are not to be missed. No

BLACKSMITHS, c. 1894

luxury automobiles are more richly dight than our farm gear, in kingfisher dyes; paint is a pleasure to many a village. A stack of Prussian-blue and ochre-red baskets beside a primrose-yellow cart, with the quieter yellow of the haystack and the faded rose of the cow-houses beyond, are our primitive achievement.

The local arts, of course, may be seen more in their glory at the village church, and without having taken a survey I should be willing to assert that through the land one village in two has a church of interest. In some parts, as East Anglia, the explorer can hardly go wrong. Restoration in the last century has admittedly reduced the treasury of country craftsmanship in these churches, but much remains. The carpenter and mason and smith since the Norman Conquest have left us screen and font, pulpit and door, pew and chest and lock. For my part, I can never cease to marvel at the noble designing and the variety of memorials within the churches and in the churchyards; some of them on the walls, some among the flagstones of the aisles and passages, so many standing above the grass and its wild flowers. It is not the elaborate sculptures celebrating the wealthiest and most distinguished families who have held the manor or the hall that are in my mind's eye now, for these must have been largely imported from the studios of the metropolis; it is the plain tablet or the modestly embellished headstone. We talk of calligraphy

HIGH STREET, DORCHESTER, 1887

nowadays with respect, and a man with a high sense of
it may make a great name—the late admirable Eric
Gill, for example; but the anonymous artisan of the
English village during its mild career has been endless-
ly 'correct' in this pure art, so far as it is executed with
the chisel on stone. A few minutes spent in examining
the floor of such a church as Dorchester, Oxon., will
illustrate this unambitious mastery; a longer and wider
study will show how the freedom of the individual
craftsman has flourished without ever deserting the
principles of symmetry and clarity and dignity. Some
time in the Victorian period a change of religious sen-
sibility intervened upon that native classicism, but it is
still a striking element; and wherever too the church
walls are hung with old hatchments, and the Royal
arms, and perpetuations of deeds of alms or of bell-
ringing, the strength and sense of our village memorial-
ists appear as well. If you are curious about the character
of the Englishman, not so much at one moment of
national experience as in the main, these are the kind of
evidences which arose spontaneously and may be
called profound.

When the poet Wordsworth returned to this country
from one of his continental tours, he was particularly
delighted with the sight, suddenly become uncom-
monly vivid, of cattle moving and feeding in the fields
where and as they would. Perhaps there is no such rarity

in that arrangement to-day as would deserve his special patronage; but the English village has always been very well shared between its human inhabitants and the others. Horse, cow, pig, sheep, fowl have a good standing here, and know their way about as well as the postman; from this understanding between them and their guardians it has come that England has contributed so much and obtained due reward in the world of live stock beyond seas. An affection, which is seldom assessed in detachment, has always existed between the farmer's man or boy and his beasts. I remember not many years ago that there was a strike called of agricultural labourers. They came out; but, as I went on my morning rounds, I saw them shyly hanging about near the pens and stables, unable to leave their horses and cows untended for more than a few hours. As has been often said, these men are not sentimental about animals' rights, and can and must be at times abrupt and hard; there is no mercy for a mole though he is a beautiful little fellow, no question about ferrets being sent into the rabbit-warren when the market wants rabbits, and no remorse when the clever old pig who used almost to talk about the weather and crops is to become pork—but the rule is to be kind. So, a Wordsworthian happiness is to be found daily in any village lane or lea, and the scene is rich with sauntering herds and flocks, unanxious, living their own lives, obedient only to

those whom they recognise as their masters and vict-
uallers.

If much that these brief pages contain be found
laudatory and optimistic, I cannot help it, and do not
regret it; but it is not to be explained away as due to the
bias of association. These things, touched upon with a
reserve in fact, are actual. Another characteristic of
many English villages rises in fair forms to my reflec-
tion: the happiness of children in such places. Many
dreary and imprisoned villages there are, under the
shadow of huge industrial organisation, and blackened
nature might shriek to heaven against what they
impose on young life; but it is to the better and best
that we must look, and of those there is abundance.
Our picture of an English village naturally includes
groups of children at their games or on their travels,
for which there is ample room and shining liberty. The
child Charles Lamb and some of his companions, in
the days of King George III, set forth on daylong expe-
ditions in the spirit of the explorer who was then
attempting to trace the Nile to its source; and the same
adventurous pastime is known to the children of our
countryside in the reign of King George VI. For just
beyond the houses of the village the wide territory is
spread still: the merry meadow stream still ranges on
from jewelly shallow to sleepy shadowy pool; the
pigeons still fluster with vast din through the cool and

AGRICULTURAL LABOURERS, NINETEENTH-CENTURY

hushed wild-wood; the skylarks arise with their invincible singing from somewhere in the young corn towards the fleets of sunshine clouds. The bluebells flood the brake, the cowslips tassel the dyke in their multitude as the season advances, and the hedgehog is surprised on his way through the old fence with its snail-shells and tumbled cones and crab-apples, or the lizard and grass-snake are there for a moment by the brushwood pile; it is a fairyland of natural secrets, and must be the best school in the world. When we have time again to think over the preservation of rural England, may the vision of the child in the meadows be constantly present to the minds of our counsellors and law-makers.

The subject cannot be left, even in these brief paragraphs, without one word for the 'charm of birds' which blesses the English village. A villager might not be heard often to refer to it, and possibly he would have professional reasons for objecting to the busy beaks which, perhaps, do not always help his fruit trees; but his orchards and gardens and hedgerows and spinneys and ponds have enriched the village with a delight unequalled elsewhere. Not for long in the year is the chorus silent, but when it returns in its full wonder one may think anew of the English village and the Latin poet's lines as transferable to it:

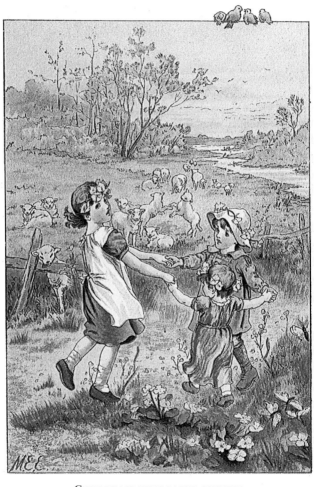

CHILDREN PLAYING IN THE COUNTRY
'. . . the happiness of children in such places.'

O fortunatos nimium sua si bona norint
Agricolas!

Here the singers congregate, and I have stayed awake
through nights in March to witness as far as the eye
may and to hear in all its immortality the hymn they
sing to the coming sun out of hedges as yet leafless or
nearly. The thing is a triumph and a mystery. But per-
haps not more so than the single storm-thrush's loud
melody in the winter twilight ringing with utter confi-
dence from the tip of some bare tree against the brassy
light; or than the robin's pure fluting from the top of
the old spade in the garden, while the old lady shuts up
her fowls for the night. Let those who know their birds
give this theme its full utterance, as so many have done;
but let the lover of the English village not fail to reckon
this as a part of its inheritance, not less noteworthy than
its architecture or its personalia.

And then, however widespread through the peo-
ples of the world the gospel of flowers may be, nowhere
has it been longer accepted and beloved than in these
villages of ours. It is a topic which admits of no novelty
at this time, unless the expert gardener will tell us of
changes and improvements, and discoveries which
concern the eager florist of the village; but there is no
resisting the radiance and fantasy and perfume of it all.
These cottages of ours, be it confessed, are often 'battered

and decayed' and of nothing but an odd or pathetic
beauty in themselves, but give them their charm of
gardens and they are beyond criticism. One has passed
so many and so many of them in all their coloured mas-
querade, frolic and gentle; no need to sort out their
flowers and their trees with scientific precision.
Enough to dream again on a winter's day of the lovely
profusions which the villager accepts as the ordinary
and unlaboured due of the calendar: the polyanthus,
the crocus, wallflower, pansy, nasturtium, tulip, laven-
der, stock, tiger-lily, sunflower would merely begin the
catalogue. The rose is well attended. With the flowers,
one has a mist of remembrance of the bushes and
shrubs, the currant and gooseberry, the privet, holly,
box and myrtle—the ivy, the jessamine, the vine on the
walls and about the porch—the whole a chance-medley
but a true garland for our village spirit. The matter does
not end there, for along the path to the well or the allot-
ment the half-civilised flowers are as welcome, above
all the honeysuckle pink and white, the vetches yellow
and blue, and the great and small trumpets of the
bindweed. And one word more for some of our trees, for
the limes before the old shops, with the south-west wind
and the summer shower in them; for the walnut-tree,
especially when its winter boughs and twigs on a pale sky
make so delicate a network; for the yew in the church-
yard, with its gloom and grandeur. Or we may look out

over the stone fence and the goose-walk at the brown and honestly ugly pollards round the spring, the grey-silver and simply exquisite aspens along the track beyond; and light upon 'the delicious green patches, the islets of wilderness amidst cultivation,' the flamy gorse and powder-green juniper which survive delightfully within the immediate bounds of the village. The pigeons and the bees may make an undersong all this time, or the lustier sounds from trough and midden.

If an individual in 1940, writing on these affairs, were assailed as a pedlar of his own caprices, he might protect his case by allusion to the remarkable literature which his countrymen have already produced in the same enthusiasm and which has been on the increase for the past half-century. It includes not only direct interpreters but some of our greatest imaginative creators, from Jane Austen to Thomas Hardy. The direct interpreters may be grouped roughly under one or two great names from the late eighteenth or early nineteenth century. For the sterner, the pessimistic view of an English village, the poet George Crabbe was perhaps the earliest spokesman, and nobody has beaten him in his way though the modern anti-Arcadian has had greater licence to mention some of his dark anatomies. For the temperate appreciation of the entire village, without social questionings or presages of upheaval, Gilbert White of Selborne is immortalised, though he professed

to offer little more than natural history. The verse of
John Clare, a villager of peculiar vision, displays the
surprising multiplicity of action and passion, of char-
acter and accomplishment found within the walk of life
to which he was born. A lady of extraordinary knowl-
edge and sympathy, Mary Mitford, has put forward the
brighter side of village life, indoors and out, in a classic
which still lives and still answers particular moments
perfectly. To these originals most subsequent writings
may be broadly referred; but latterly, and on very good
grounds, the authors of village books have been more
and more inspired by the figure, one might almost say
of Piers the Plowman, at all events of the man and
woman who form the country community. The text is
'See yonder stubborn lump of flesh who sings behind
his spade,' but it is developed into an exposition of his
works and days as being still the vital part of English
life. This man must go on, with restored assurance and
with fuller opportunities.

It would be silly to pretend that every villager is
the exemplar of this rustic ability. The difference
between man and man is not confined to any one circle.
Leadership is called for in the village as elsewhere, and is
not found invariably. But, when it appears, things pros-
per, the best is likely to be maintained, the work is done
and the games are played. It is one of the satisfactions
of life in an English village to become acquainted with

one or other of the men and women on whom the fabric rests most. These have silent authority, and live for anything but material advantage. No weather is so wild, no circumstance so unpromising but they will be fixing up something at need. They are not only resourceful; they have a courtesy which one may sometimes realise only at an interval of time from some particular piece of valuable arrangement or decision.

It may be asked where the most gracious and perfect of English villages are to be found. And the answer is not within my power to give. To judge by recent preferences, the 'Cotswold constellation' and the East Anglian kind with their spacious and fine churches must compete for the highest award. If one had no more of the whole multitude than these, it would be still a marvellous possession of the sense and spirit. I may mention a trio of villages which obtain a place in the notes of Mr. Charles Bradley Ford on this comparative study: he is speaking 'of the village that spreads into several distinct clusters—one, perhaps, around a green of its own, another along a tree-fringed lane, a third centred round the churchyard or the pond. Composite villages of this type are Finchingfield in Essex, Hartest in Suffolk and Steventon in Berkshire—which, it may be added, are three of the most charming in the country.' These indications come from one of the keenest judges of the English village

VILLAGERS, c. 1840

'The figure . . . of the man and woman
who form the country community.'

living; but, as he also remarks, 'the charm of the English village lies in its fortuitousness.' There is no real way of directing the stranger to the place which, with this as a condition, will appear to him pre-eminently adorable or ready for his prolonged sojourn. But he has a choice of a great many, and will probably come to regard one favourite village as having more virtues than the others, and he will be right; for it is only by deep and sweet intimacy that these will be revealed, by a single love-affair.

colour plates

The Thames near Goring
– Watercolour by H. Jutsum

Tottenham Village in 1822
– Watercolour by George Scharf the elder

A Yeoman Farmer
– Oil painting by Neville Lytton

The Village Flower and Vegetable Show
– Oil painting by Gilbert Spencer

Iffley from the Towing Path, Oxford
– Watercolour by Peter de Wint

Thatching in Hampshire
– Oil painting by Richard Eurich

Moston: A Norfolk village
– Watercolour by Martin Hardie

An English village
– Watercolour by John Constable

black & white plates

Broadway, Worcestershire, 1889
Haworth church and Parsonage 1857
St Peter's, Kent, 1865
Cattle grazing by a stream, 19th century
Devonshire Village, 1883
A Butcher's shop, 1838
The Grammar School, Steyning, Sussex
The apple harvest
Halstead, Essex
A windmill in Lincolnshire
Market Drayton, Shropshire
Thatched Cottage, 1899
King's Head, Aylesbury, 1879
Leamington, Warwickshire, 1830
Cherry Tree Cottage, Chiddingford, *c.* 1890
Whitchurch, Dorset
Boys tossing for innings, 19th century
March Fair at Brough, *c.* 1825
Labourer's Cottage, East Morden, Dorset, 19th century
The Village Festival, 18th century
Blacksmiths *c.* 1894

English Villages

High Street, Dorchester, 1887
Agricultural Labourers, 19th century
Children playing in the country
Village Street, Suffolk 19th century
Villagers, *c*. 1840

Acknowledgments

PRION HAVE ENDEAVOURED TO OBSERVE THE LEGAL requirements with regard to the rights of suppliers of illustrative material and would like to thank Mary Evans Picture Library and The Francis Frith Collection (Shaftesbury, Dorset) for their generous assistance.